URNER
ater Works

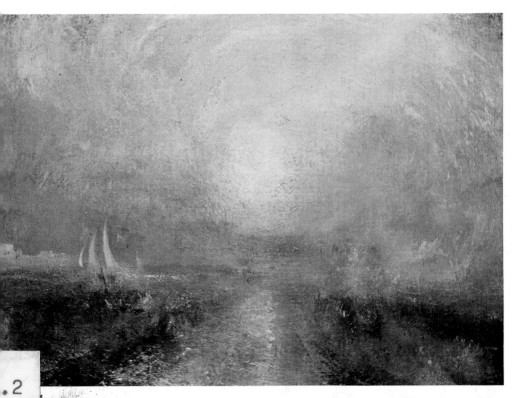

The Early Works of J. M. W. TURNER

The Early Works of J. M. W. TURNER

by Mary Chamot

TATE GALLERY Published by Order of the Trustees 1965

Note

The Turner collection at the Tate Gallery normally occupies galleries VI, VII, VIII, IX and X. In addition to works in the Tate Gallery's own collection mention is made of some in other public collections, particularly the National Gallery with which oil paintings from the Turner Bequest are sometimes exchanged. In the winter months gallery X is hung with watercolours, mainly selected from those in the Turner Bequest now in the care of the British Museum Print Room. As the selection is changed from time to time references are not to individual examples but to the Roman numerals under which sketchbooks and groups of associated works have been catalogued, for example 'T.B. LXXI'. The Tate Gallery's catalogue numbers of the works reproduced are given at the end of each caption and in the list of plates.

A companion booklet by Martin Butlin on Turner's later paintings in the Tate Gallery is being published at the same time.

Published by the Publications Department, the Tate Gallery, Millbank, London, S.W.1. Printed in Great Britain at The Curwen Press, Plaistow, E.13

24 *St. Mawes at the Pilchard Season.*
exh. 1812.
Canvas, 36×48 in. (484)

25 *Shipping at the Mouth of the Thames.*
*c.*1807–10
Canvas, 33¾×46 in. (2702)

26 *Appulia in search of Appulus.—Vide Ovid.*
exh. 1814
Canvas, 59×94½ in. (495)

27 *Crossing the Brook.* exh. 1815
Canvas, 76×65 in. (497)

28 *Entrance of the Meuse: Orange-merchant
on the Bar, going to Pieces; Brill Church
bearing S.E. by S., Masensluys E. by S.*
exh. 1819
Canvas, 69×97 in. (501)

29 *England: Richmond Hill, on the Prince
Regent's Birthday.* exh. 1819.
Canvas, 71¾×132 in. (502)

30 *The Decline of the
Carthaginian Empire.* exh. 1817
Canvas, 67×96 in. (499)

TURNER'S EARLY PAINTINGS, 1796–1819

The Tate Gallery has the largest collection of Turner's oil paintings, covering his work from the time he first began to exhibit to the year before his death. His importance as a landscape painter was proclaimed in his life-time by Ruskin with a passionate fervour that few artists have succeeded in arousing among their contemporaries. Today he is admired for quite other reasons and the selection of his work on view differs from the display, restricted to his finished pictures, shown to the public when his bequest came into the possession of the National Gallery. These facts indicate the breadth of his achievement, for he not only satisfied the romantic taste of his own day, but anticipated the generalized vision of the Impressionists and, however different his aims, even arrived at something like mid-twentieth century abstract-impressionism in the oil sketches, which had never been seen by the public until at least half a century after his death. In fact the immense wealth of the Turner Bequest continues to produce fresh surprises as more canvases are cleaned and put on view.

In the summer of 1931 a large exhibition of Turner's early oil paintings was held at the Tate Gallery, covering the period 1796–1815, and including some pictures from private collections as well as fifty-nine from the Turner Bequest. It was hoped to follow this with an equally full survey of his later work, but for a variety of reasons, culminating in the outbreak of war, this project never materialized, though some sketches were shown in 1939. After the war a representative collection

of oil-paintings together with a selection of watercolours was sent to the Venice Biennale in 1948 and toured a number of European capitals, enabling people on the Continent to appreciate his genius for the first time. Although a complete showing of Turner's works in the national collections, such as he envisaged in his ambiguously worded will, has never been realized, the Tate now has five rooms, built by Sir Joseph Duveen in 1908–10, permanently hung with the best of the oil paintings in the collection, numbering around 280 in all.

Joseph Mallord William Turner was born in London on 23 April 1775, the son of a barber in humble circumstances, who had a shop off the Strand. He was astonishingly precocious as a child and the earliest dated drawings in the Turner Bequest, now in the British Museum Print Room (T.B. I), were done when he was only twelve. Like most artists of his day, he learnt to draw by copying the work of others, but by 1789 he appears to have begun the practice he was to continue all his life, of travelling about during the summer, making notes from nature in pencil or watercolour, which could be used afterwards as material for pictures. In the same year he entered the Royal Academy Schools, having previously received some instruction from Thomas Malton and Edward Dayes. Probably the most formative influence in these early years was the encouragement of Dr. Munro, who used to invite Turner, Girtin and other young artists to his house and set them to copy his collection of watercolours by J. R. Cozens.

Turner began to exhibit watercolours in the Royal Academy in 1790 and his first oil 'Fishermen at Sea' appeared in 1796 (on loan to the Tate Gallery from Francis Fairfax Cholmeley since 1931). A comparison of the greenish tone of this sea-piece with the more mauve colour of

the 'Moonlight: a Study at Millbank' (plate 3), exhibited the following year, reveals his sensitive eye for colour, even in dark night scenes. Turner's subsequent development was a slow but steady progress towards more light and purer colour.

In 1798 he exhibited two views of the Lake District, which he had visited the previous summer, 'Morning among the Coniston Fells, Cumberland', with a quotation from Milton, and 'Buttermere Lake with Part of Cromackwater—a Shower' (plate 4), with a rainbow and a quotation from Thomson's *Seasons*. During these early years of growing success he was evidently improving his mind by extensive reading, as his schooling had been of short duration. His earnestness of purpose is reflected in the self-portrait (plate 2). At the same time he was exercising his technical resources by painting pictures deliberately in the style of the masters he most admired. He had already visited Wales, probably drawn there by his admiration for Richard Wilson, and he now tried his hand at the Wilsonian style of classical composition in 'Æneas with the Sibyl: Lake Avernus' (plate 5) as well as painting some views of Welsh scenery and the gracefully designed 'Clapham Common' (plate 7), though this shows less of Wilson's conventions and is more directly based on the actual scene.

In 1799 he was elected A.R.A.; by 1800 he had established himself in Harley Street, where he was to build his own Gallery for periodical display of his latest works, and in 1802 he became a full member of the Royal Academy. That year Turner went abroad for the first time, when it became possible to do so after the Peace of Amiens. He set out for Paris in July, proceeded to Switzerland via Lyons and Grenoble, toured the regions of Mont Blanc, Val d'Aosta, St. Gothard, Schaffhausen and

returned through Nancy to Paris, where he made extensive notes on the old masters assembed by Napoleon at the Louvre. Altogether he filled eight sketchbooks with some five hundred drawings during the tour (T.B. LXXI–LXXXI).

The result of this was a series of pictures more ambitious and varied than he had previously attempted. Vivid memories of his rough Channel crossings inspired him to paint 'Calais Pier, with French Poissards preparing for Sea: an English Packet arriving' (plate 1). Here and in the 'Shipwreck' exhibited two years later, but probably painted about the same time, his mastery in painting a stormy sea appears coupled with a new and more emphatic use of chiaroscuro, giving drama and depth to the design. At the same time he preserved a delicate juxtaposition of blue, grey, red, mauve and yellow colours in the clothes of the figures.

Turner had seen works by Poussin in English private collections and had exhibited 'The Tenth Plague of Egypt' in 1802. During the next decade he painted several more biblical and classical compositions with emphasis on architectural structure, such as 'The Destruction of Sodom' (plate 10), 'The Goddess of Discord choosing the Apple of Contention in the Garden of the Hesperides'. 'Apollo and Python', two views of Bonneville, which were sold, and 'The Vintage at Macon', now in the Sheffield Art Gallery. His admiration for Titian found expression in 'Venus and Adonis' (formerly on loan to the Gallery and now in the Huntington Hartford Gallery of Modern Art, New York) and in the 'Holy Family' (plate 8), originally also planned as an upright composition with angels above, according to a drawing (T.B. LXXXI). The colour of these pictures has almost certainly darkened with time, but Turner's notes made in the Louvre show him to have been critical of garish colour in

many of the pictures he saw. It was only some twenty years later that he himself began to use purer colours and banished the 'gallery tone'. His late figure painting reflects the glowing reds and golds of Rembrandt, but in these early years he confined himself to more sober interiors with figures in the manner of Teniers, possibly in rivalry with Wilkie. 'A Country Blacksmith disputing upon the Price of Iron, and the Price charged to the Butcher for shoeing his Pony' (plate 12), exhibited in 1807, is proudly inscribed: J. M. W. Turner R.A. It is one of the pictures Turner bought back at the De Tabley Sale in 1827, together with 'The Shipwreck' and 'Sun rising through Vapour' (N.G.), for more than he had been paid originally. Hardly any of the pictures in the Bequest bear a signature; probably he was not in the habit of signing his work before it was sold, or unless requested to do so by the purchaser. He now had a growing circle of patrons among whom the third Earl of Egremont remained his lifelong friend. The list of subscribers to the first of his pictures to be engraved, 'The Shipwreck' of 1805, contains many distinguished names.

In addition to classical and mythological subjects he attempted a contemporary historical subject, the death of Nelson, exhibited in his own Gallery in 1806: 'The Battle of Trafalgar, as seen from the mizen starboard Shrouds of the Victory' (plate 11). Here he was able to combine his knowledge of shipping with the interest of a topical event, but the picture remained unsold. Many years later in 1823 he was commissioned to paint a large picture of the Battle of Trafalgar for St. James's Palace, now in the National Maritime Museum, Greenwich.

From about 1807 Turner began to exhibit more landscapes of English scenery, though still painting occasional subjects in emulation of the

old masters. The landscapes, mostly of the Thames Valley, show a careful study of tone values and atmospheric effects in a higher key and without the heavy contrasts of his earlier compositions (cover and plates 13, 16 and 20). It was probably during the summer of 1807 that Turner made the oil sketches of Thames scenery, evidently direct from nature, from a boat. Some of these are painted on thin mahogany, the reddish wood often showing through the rapidly applied brushstrokes (plate 9). The immediate rendering of the relation of treetops and buildings to skies taught Turner a new understanding of landscape and shows surprising similarities to the almost contemporary sketches by Constable, such as the 'View of Epsom' (Tate Gallery, No. 1818), and also to the somewhat later outdoor work of the French painter Corot. Some of the sketchbooks, filled with drawings and watercolours of the river, are, like the oil-sketches, unusual in their long horizontal shape, so well suited to the subject of a river bank (T.B., XCVI, XCIX, etc.). The son of the Reverend Henry Scott Trimmer, Turner's old friend and executor, has recorded, according to Thornbury, that Turner used to paint large canvases direct from nature from his boat: 'In my judgement these are among his very finest productions: no retouchings, everything firmly in its place . . . This is the perfection of his art, but Turner's mind was so comprehensive that he could not carry out the detail though he was far from despising it.' Plates 6, 15, 17, 18 and 22 are probably among the pictures Trimmer had in mind.

A number of reasons could be put forward for the good fortune that these canvases were never finished. Some were discarded and the subject was repeated on another canvas (plate 16). Turner was overwhelmed with work during this decade, including commissions for views of country seats, like 'Somer Hill' in Edinburgh, and no doubt began more canvases

than he would ever have had time to finish. He had just embarked on a new venture to produce a series of engravings which he entitled *Liber Studiorum* and continued to work at until he finally gave up in 1819. The subjects of over a dozen of his earlier pictures were used for some of the plates (see plates 16, 20 and 26) and the project served to give his work a wide publicity. But probably the chief reason why Turner left so many vivid direct studies in their pristine condition is that he realized how much the 'finish' demanded by the public would detract from their quality. The difference seen by a comparison of the sketches (plates 6, 9, 14, 15, 17, 18, 22 and 25) with the exhibited pictures (cover and plates 13, 16 and 20) is even more apparent in front of the actual paintings. The figures in particular, often so inarticulate and blurred in the finished pictures, seem to fit into the landscape better when indicated only by a few apt touches of colour without any attempt at modelling.

The effect of a windswept sea with boats rising and falling is dramatically rendered in the slight sketch 'Shipping at the Mouth of the Thames' (plate 25), probably painted at about the same time as the other Thames sketches, and in the more ambitious blustery sea-piece 'Spithead: Boat's Crew recovering an Anchor' (plate 19). The title in the Royal Academy catalogue does not indicate the real subject, which represents two of the Danish ships, seized at Copenhagen, entering Portsmouth Harbour. Turner had made a special journey down to see the arrival of the squadron, but it was dispersed by bad weather and he only saw the arrival of two ships, which he recorded in a sketchbook and then developed in the picture. Perhaps it was the topical nature of the subject which led him to exhibit it in his own Gallery, as he had previously shown his 'Trafalgar', before it was finished. As a rule he was extremely secretive about the progress and methods of his work and never had any

pupils or assistants in his studio. 'Bligh Sand, near Sheerness: Fishing Boats trawling' (cover) is also reminiscent of the Dutch masters, but, as usual, shows his own powers of observation in the light and colour playing on the sails and suggesting a breeze.

There seems to be no doubt that the general public appreciated Turner's paintings of familiar English scenery with its diffused light and haze, although the connoisseurs, personified by Sir George Beaumont, carried on a campaign against his endeavour 'to make painting in oil appear like watercolour'. Turner and his followers were dubbed 'the white painters' because they no longer covered their paintings with black and brown. One of the most revolutionary pictures in this respect was Turner's 'Frosty Morning' (plate 23) perpetuating a scene he had remembered on a journey to Yorkshire. It is one of the first instances of his abandoning the conventional composition of a dark foreground and a luminous distance taking the eye inward into the centre. Here the spectator is invited to follow two paths diverging sideways, the road on the left with the stage coach in the distance and the gate on the right towards the sun, thus giving a far greater illusion of limitless space. The retentiveness of Turner's memory and the use to which he put effects he had seen is exemplified in the picture 'Snow Storm: Hannibal and his Army crossing the Alps' (plate 21). The mountain setting was based on studies he had made on his first journey to Switzerland, as was also 'Cottage destroyed by an Avalanche', but the storm was one he had witnessed while staying with his friend Walter Fawkes at Farnley Hall in Yorkshire.

In 1811 he paid his first visit to Devonshire and went again in 1813. In 'St. Mawes at the Pilchard Season' (plate 24) he found a subject after his

own heart and treated it more colourfully than his earlier shipping and harbour scenes. He made small oil sketches as well as watercolours on this tour and the scenery inspired him to paint several pictures in the manner of Claude. This artist does not appear to have evoked any comment from Turner in Paris, perhaps because he had seen better examples in England. In 1814 he exhibited at the British Institution, in a contest for the best landscape in the manner of Claude or Poussin, the closest imitation of Claude he ever produced, 'Appulia in search of Appulus.—Vide Ovid' (plate 26), a variant of Claude's picture at Petworth of 'Jacob with Laban and his Daughters'. The placing of the trees, the distant hills, the bridge in the middle distance and the figures in the foreground are almost identical, but Turner lacks the lucidity of Claude and suggests a Northern haze rather than the clear Roman light. In the same year in the Academy he showed 'Dido and Æneas', the first of his Carthaginian subjects, though Devon features have been recognized in the landscape. 'Crossing the Brook' shown the following year (plate 27), so Claudian in character that it has often been taken for an Italian scene, is actually a view of the Tamar valley.

It has been suggested by Thornbury and others that Turner's predilection for Carthaginian subjects may have been due to the patriotic feelings stirred by the Napoleonic wars and to a parallel he saw between the rise of Carthage as a maritime power and that of England. Compositions of classical harbours occur in some of the Thames sketchbooks, but it is not certain whether he spent his evenings while on the river working out these designs or used the blank pages of the same sketchbook years later. In any case it seems that, like so many modern artists, he would visualize a design, put it down on paper, and then find an appropriate title. Several alternate titles are inscribed on some drawings (T.B. XC).

Apart from Virgil, Thomson's poetry served as a source for many of his pictures; his own poetic experiments, *Fallacies of Hope,* quoted in the Academy catalogues, were mainly modelled on Thomson, just as so many of his pictures were at this time on Claude. That he deliberately intended to measure his own achievement against that of the French master is proved by his bequest of two pictures he prized most highly to the National Gallery on condition that they were hung between Claude's 'Seaport' and 'Mill'. One of these was 'Dido building Carthage', which was universally admired when it was first exhibited in 1815.

In 1817 Turner made his second journey abroad, this time to Belgium, Holland and up the Rhine, filling his sketchbooks with material for future use, but the only records of this tour in the Gallery are the rather turgid moonlit 'Field of Waterloo' strewn with dead bodies after the battle, and 'Entrance of the Meuse' (plate 28), a stormy sea-piece with a very low horizon-line and a cloud-swept but luminous sky. The most successful work, the famous 'Dort', painted in evident emulation of Cuyp, was sold to Walter Fawkes and is still at Farnley Hall. Most of the watercolours recording this tour were also purchased by Fawkes.

During the spring of 1819 two retrospective exhibitions of Turner's work were held. Sir John Leicester, who had been a regular patron for years and owned eight of Turner's important pictures, as well as works by his contemporaries, opened his London house to the public, and Walter Fawkes followed suit with a display of over sixty of his finest water-colours. Catalogues were printed of both collections, and these private exhibitions, together with his contributions to the Royal Academy, brought Turner's name prominently before the public. Turner's last two pictures, shown before he set out for Italy in August, were an epitome

of his work up to that time, the 'Meuse' as a sea painter and the huge 'England: Richmond Hill, on the Prince Regent's Birthday' (plate 29) as a landscape painter in the tradition of Claude but with contemporary figures and representing an actual scene, so harmonious that it needed no artificial build-up. Perhaps the quotation from Thomson, appended to the title in the Royal Academy catalogue, beginning with the words: 'Which way, Amanda, shall we bend our course?' was also significant, pointing to Turner's realization that he had reached a turning point in his career. The experience of Italian light was going to change his whole outlook on landscape, so that all the earlier pictures now seem dark and colourless by comparison. Admittedly some allowance must be made for darkening, otherwise it would be difficult to account for the complaints of 'more than a natural or allowable proportion of positive colour' levied against 'Richmond Hill' by his contemporaries. The slightly earlier 'Decline of the Carthaginian Empire' (plate 30) shows the use of orange light and violet or blue shadows to suggest relief without darkness (already evident in the distant building of 'A River, with Castle and a Village', plate 14), but these are only premonitions of the splendid colour and radiance of Turner's later works.

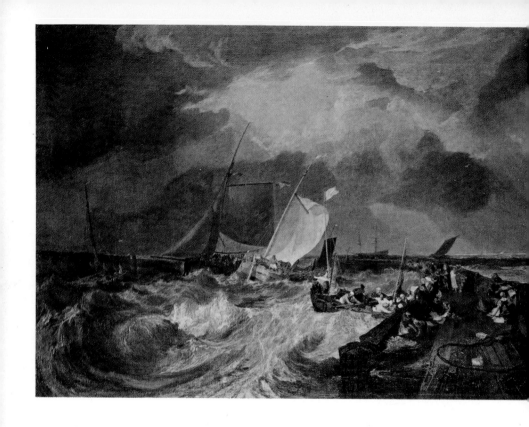

1 *Calais Pier, with French Poissards preparing for Sea: an English Packet arriving.*
exh. 1803
Canvas, 68×95¼ in. (472)

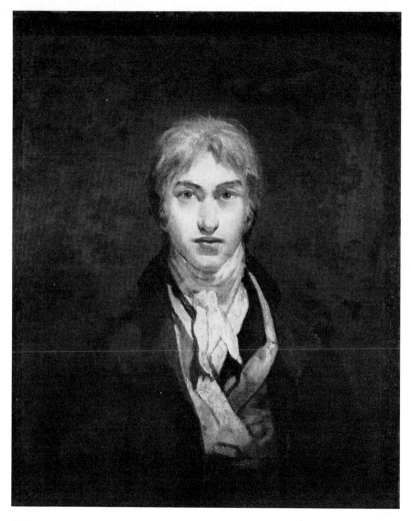

2 *Portrait of the Artist when young. c.*1798 Canvas, $29\frac{1}{2} \times 23\frac{1}{4}$ in. (458)

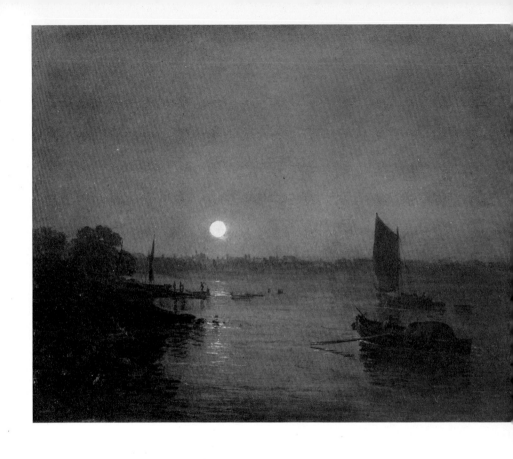

3 *Moonlight: a Study at Millbank.* exh. 1797
Panel, 12¼×15¾ in. (459)

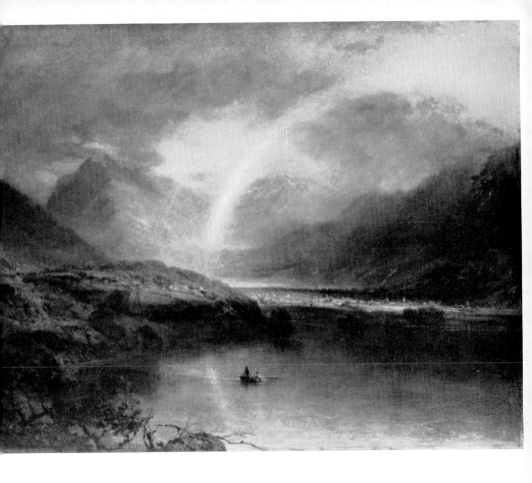

4 *Buttermere Lake, with Part of Cromack Water, Cumberland: a Shower.* exh. 1798
Canvas, 36 × 48 in. (460)

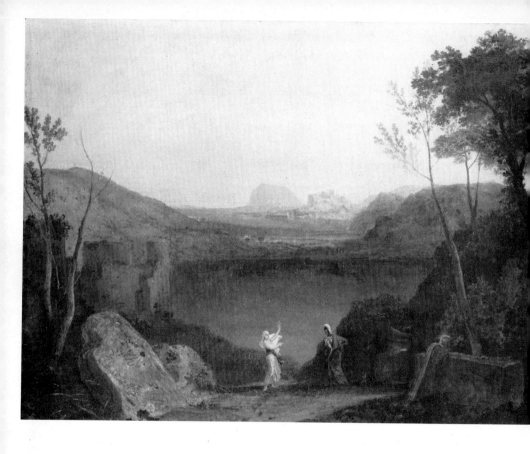

5 *Æneas with the Sibyl: Lake Avernus.* c.1800
Canvas, 30¼ × 38¾ in. (463)

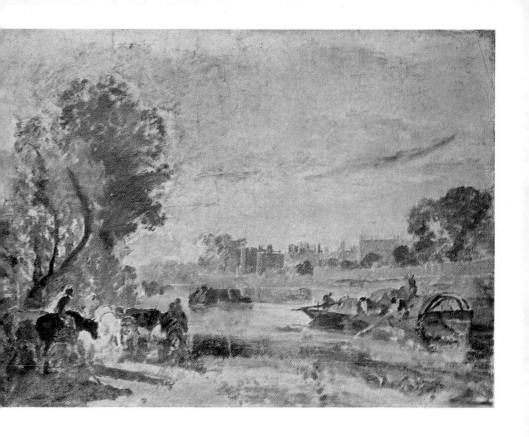

6 *Hampton Court from the Thames. c.*1807
Canvas, $33\frac{3}{4} \times 47\frac{1}{4}$ in. (2693)

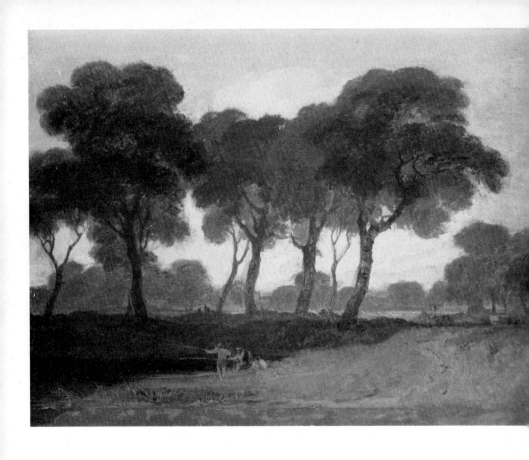

7 *View on Clapham Common. c.*1802
Panel, $12\frac{5}{8} \times 17\frac{1}{2}$ in. (468)

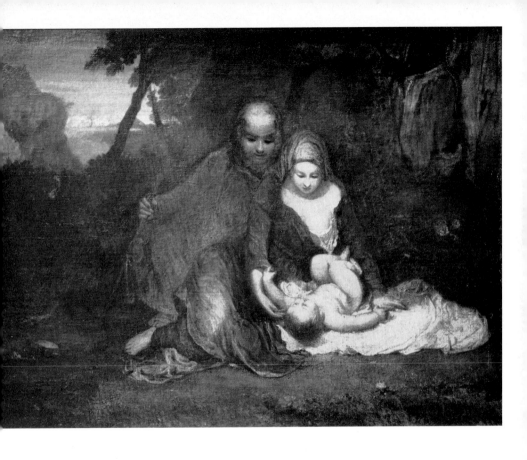

8 *Holy Family.* exh. 1803
Canvas, 40 × 56 in. (473)

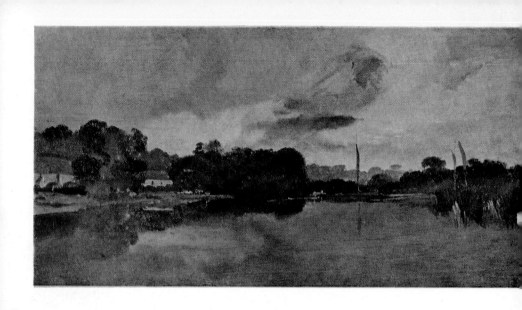

9 *Walton Reach. c.*1807
Panel, 14½×29 in. (2681)

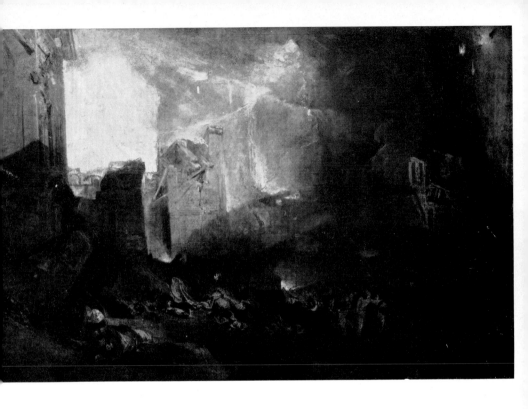

10 *The Destruction of Sodom. c.*1805
Canvas, 57½ × 93½ in. (474)

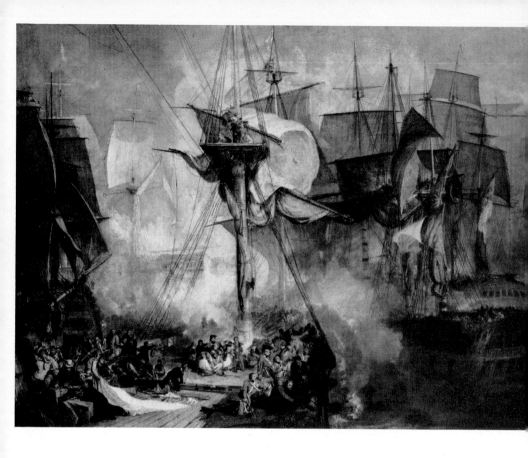

11 *Battle of Trafalgar, as seen from the mizen
starboard Shrouds of the Victory.*
exh. 1806 and 1808
Canvas, $67\frac{1}{4} \times 94$ in. (480)

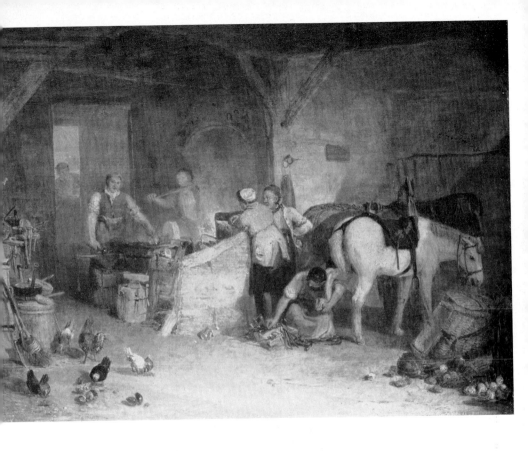

12 *A Country Blacksmith disputing upon the Price of Iron, and the price charged to the Butcher for shoeing his Pony.* exh. 1807
Panel, 21½ × 30½ in. (478)

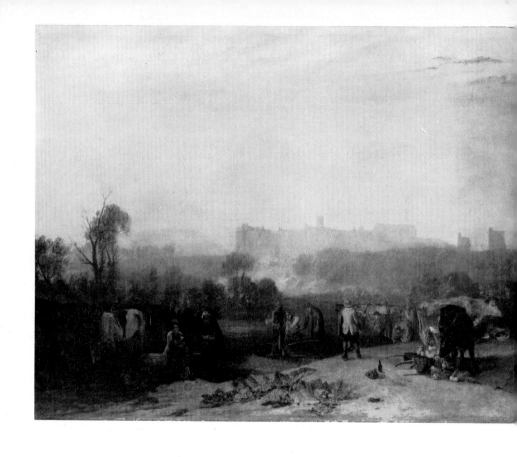

13 *Windsor, ploughing up Turnips near Slough.* exh. 1809
Canvas, $40\frac{1}{4} \times 51\frac{1}{4}$ in. (486)

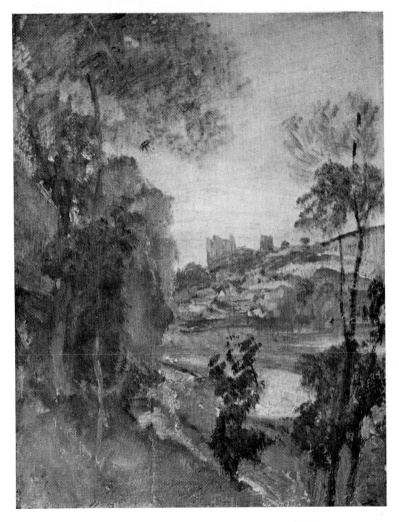

14 *A River with Castle and Village.* *c.*1807　Panel, 10×7¾ in. (2310)

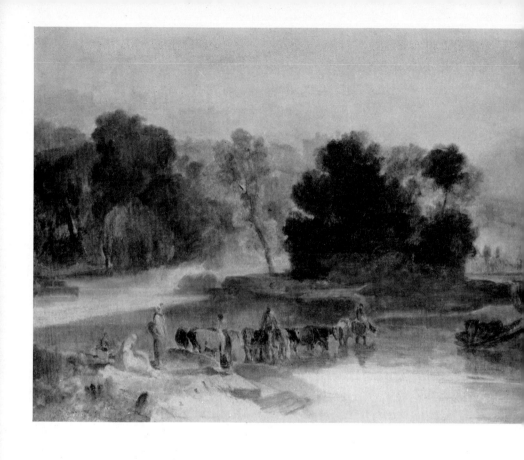

15 *Men with Horses crossing a River.* c.1807
Canvas, 34¾ × 46¾ in. (2695)

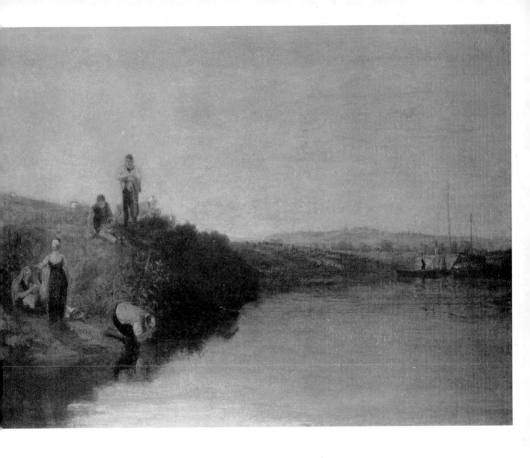

16 *Harvest Dinner, Kingston Bank.* exh. 1809
Canvas, $35\frac{1}{2} \times 47\frac{1}{2}$ in. (491)

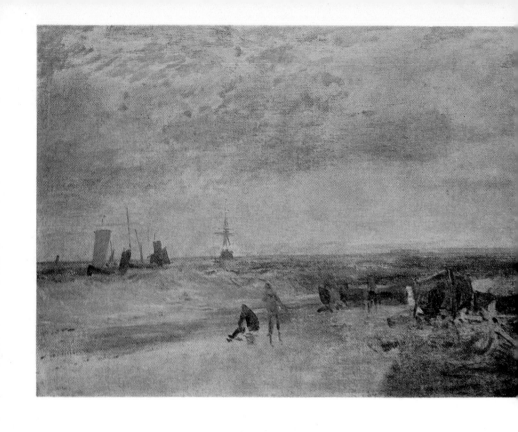

17 *Coast Scene with Fishermen and Boats.*
 *c.*1807–10
 Canvas, 33¾×46 in. (2698)

18 *Willows beside a Stream.* *c.*1807
Canvas, $33\frac{1}{2} \times 45\frac{1}{2}$ in. (2706)

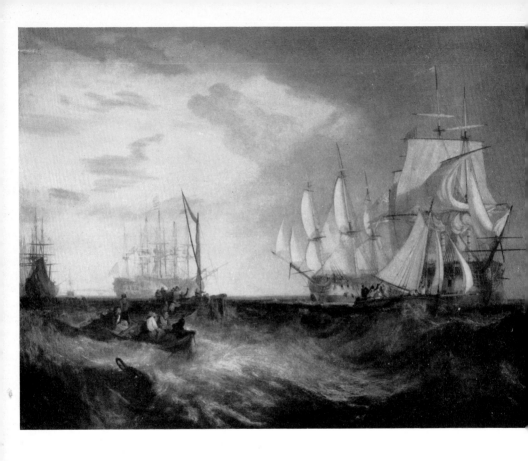

19 *Spithead: Boat's Crew recovering an Anchor.* exh. 1808 and 1809
Canvas, $67\frac{1}{2} \times 92$ in. (481)

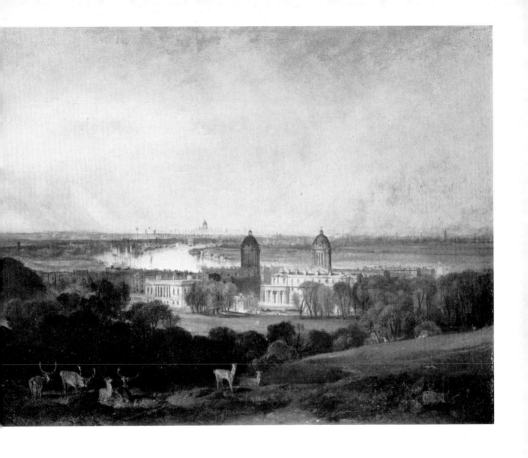

20 *London from Greenwich.* exh. 1809
Canvas, 34½×46½ in. (483)

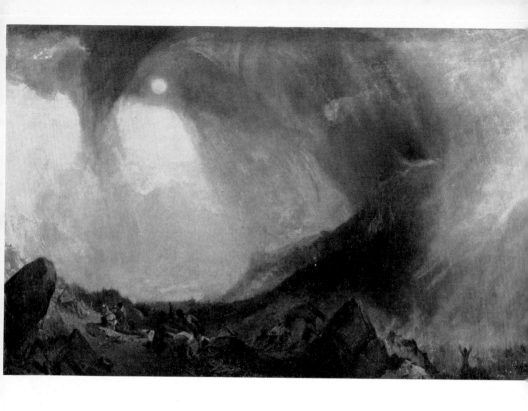

21 *Snow Storm: Hannibal and his Army crossing the Alps.* exh. 1812
Canvas, 57 × 93 in. (490)

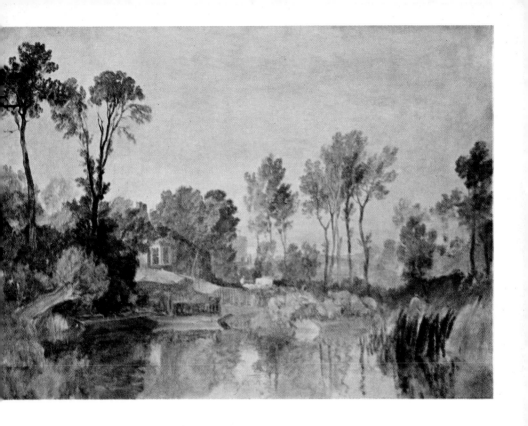

22 *House beside River with
Trees and Sheep. c.*1807
Canvas, $33\frac{3}{4} \times 46$ in. (2694)

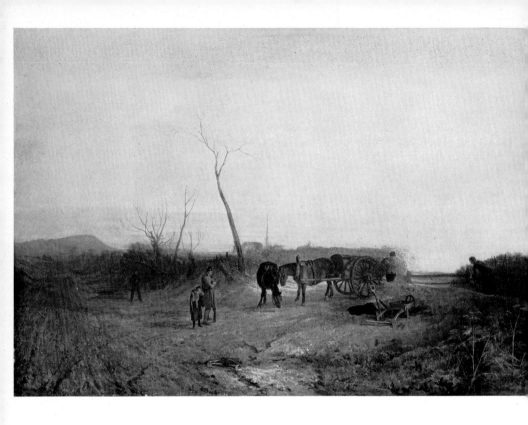

23 *Frosty Morning.* exh. 1813
Canvas, 44¾ × 68¾ in. (492)

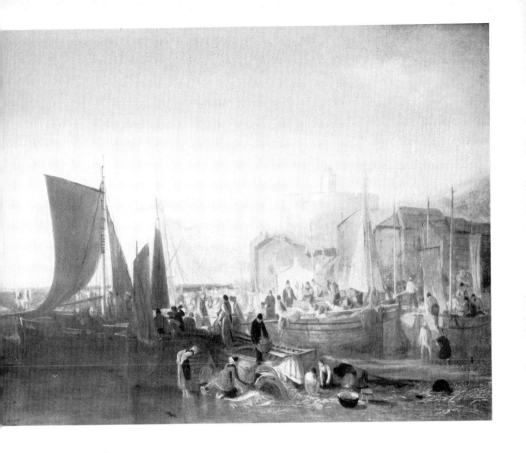

24 *St. Mawes at the Pilchard Season.*
exh. 1812
Canvas, 36 × 48 in. (484)

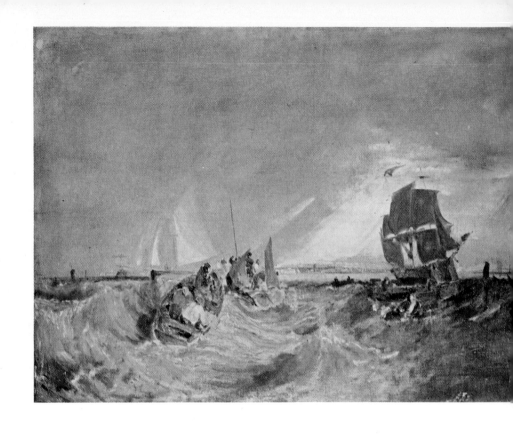

25 *Shipping at the Mouth of the Thames.*
 *c.*1807–10
 Canvas, $33\frac{3}{4} \times 46$ in. (2702)

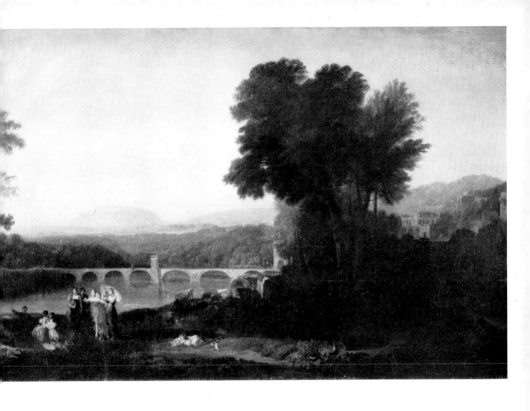

26 *Appulia in search of Appulus.—Vide Ovid.*
exh. 1814
Canvas, 59 × 94½ in. (495)

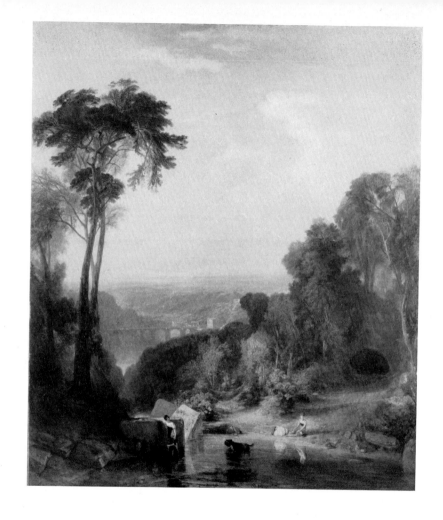

27 *Crossing the Brook.* exh. 1815
Canvas, 76 × 65 in. (497)

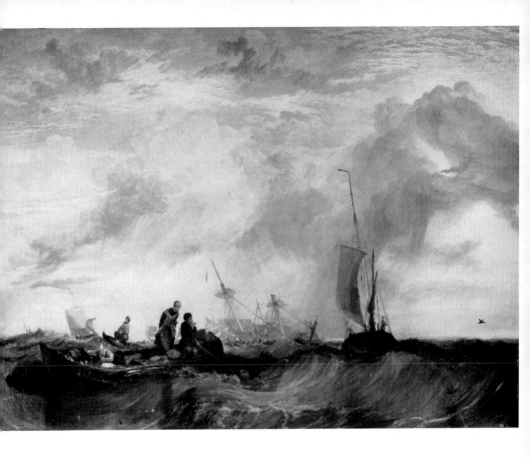

28 *Entrance of the Meuse: Orange-merchant*
on the Bar, going to Pieces; Brill Church
bearing S.E. by S., Masensluys E. by S.
exh. 1819
Canvas, 69×97 in. (501)

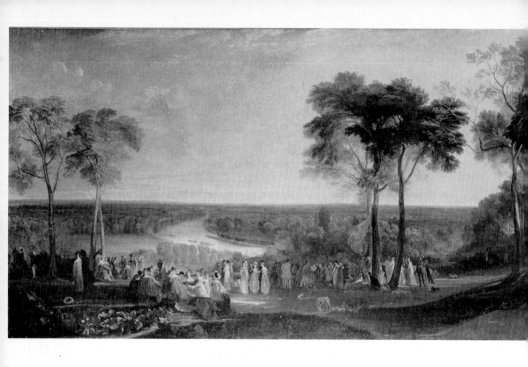

29 *England: Richmond Hill, on the Prince Regent's Birthday.* exh. 1819. Canvas, 71¾×132 in. (502)

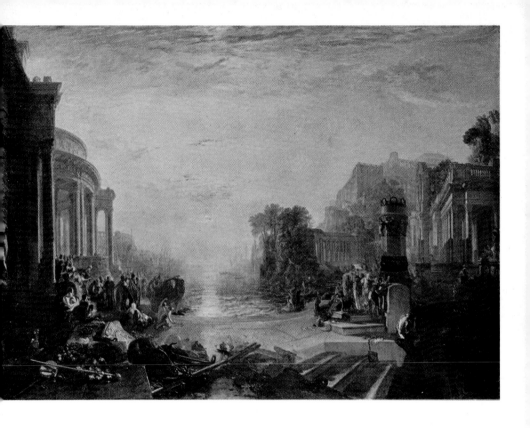

30 *The Decline of the*
Carthaginian Empire. exh. 1817
Canvas, 67×96 in. (499)

URNER
arly Works

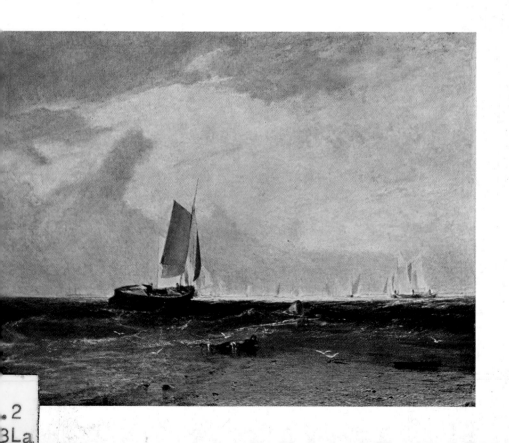

The Later Works of J. M. W. TURNER

The Later Works of J. M. W. TURNER

by Martin Butlin

TATE GALLERY Published by Order of the Trustees 1965

Note

The Turner collection at the Tate Gallery normally occupies galleries VI, VII, VIII, IX and X. In addition to works in the Tate Gallery's own collection mention is made of some in other public collections in London, particularly the National Gallery with which oil paintings from the Turner Bequest are sometimes exchanged. In the winter months gallery X is hung with watercolours, mainly selected from those in the Turner Bequest now in the care of the British Museum Print Room. As the selection is changed from time to time references are not to individual examples but to the Roman numerals under which groups of associated works have been catalogued, for example 'T.B. CLXXXI'. The Tate Gallery catalogue numbers of the works reproduced are given at the end of each caption and in the list of plates.

A companion booklet by Mary Chamot on Turner's early paintings in the Tate Gallery is being published at the same time.

Published by the Publications Department, the Tate Gallery, Millbank, London, S.W.1. Printed in Great Britain at The Curwen Press, Plaistow, E.13

25 *Peace—Burial at Sea.* 1841–42
Canvas, 34¾ × 34¾ in. (528)

26 *The Dogana, San Giorgio, Citella, from the
Steps of the Europa.* exh. 1842
Canvas, 24¾ × 36½ in. (372)

27 *Light and Colour (Goethe's Theory)—
The Morning after the Deluge—Moses
writing the Book of Genesis.* exh. 1843
Canvas, 30½ × 30½ in. (532)

28 *The Angel standing in the Sun.* exh. 1846
Canvas, 30½ × 30½ in. (550)

29 *Whalers (boiling blubber) entangled in
Flaw Ice, endeavouring to extricate
themselves.* exh. 1846
Canvas, 36 × 48 in. (547)

30 *Norham Castle, Sunrise.* c.1840–45
Canvas, 36 × 48 in. (1981)

TURNER'S LATER PAINTINGS, 1819–1850

The later works of J. M. W. Turner were dominated by light and colour to an extent unprecedented in the history of painting. This is not to say that they lack formal discipline—'Norham Castle' (plate 30), one of the most ethereal of all his oils, is nevertheless based on a compositional scheme derived from his early Poussinesque landscapes—but Turner's growing preoccupation with the forces of nature often led to new methods of composition, particularly the swirling, vortex-like designs of such works as 'Yacht approaching the Coast' (cover) and the 'Goethe's Theory' pictures (plate 27).

The qualities of light, colour and energy were implicit in Turner's earlier works but were not brought to fruition until his first visit to Italy in 1819. The overwhelming impact of the clear brilliant Italian light is shown in the watercolours done during this journey, on Lake Como, in Venice, and in and around Rome and Naples (T.B. CLXXXI, CLXXXVII and CLXXXIX). On this visit too he saw, and painted watercolours of, an eruption of Vesuvius. But the majority of the works he executed were pencil drawings and none was publicly exhibited in his lifetime. They served however as a repertoire of forms and as promptings to his exceptional visual memory, on the basis of which he could recall the excitement of his original encounter with the scene depicted.

Turner's first public demonstration of his Italian experiences was the over-ambitious 'Rome from the Vatican: Raffaelle, accompanied by La Fornarina, preparing his pictures for the decoration of the Loggia', his sole exhibit at the Royal Academy in 1820. Among the plethora of detail that clutters this vast canvas a Claudian landscape makes nonsense of the historical subject. 'Forum Romanum' (plate 3), often known as

'The Arch of Titus' and not exhibited until six years later, gives a far more successful impression of the grandeur of Rome.

Meanwhile, in 'The Bay of Baiæ, with Apollo and the Sibyl' (plate 4), exhibited in 1823, Turner had painted the first of a series of wide-spreading landscapes that do succeed in evoking the rich and sun-drenched Italian countryside. There is again a profusion of highly finished detail, including the wind-blown plume of smoke singled out by Ruskin as a special mark of Turner's landscapes. The composition, though clearly derived from Turner's earlier Claudian landscapes, is no longer based on recession by planes or diagonals but on curvilinear lines leading into depth and at the same time forming a flowing pattern on the surface of the picture. Later examples of this kind of landscape in the Tate Gallery are 'Childe Harold's Pilgrimage—Italy', exhibited in 1832, and 'Phryne going to the public bath as Venus—Demosthenes taunted by Æschines', exhibited in 1838.

Turner's second visit to Italy in 1828–29 produced less ambitious depictions of the Italian scene, such as 'Orvieto' (plate 10), actually painted and publicly exhibited in Rome. Here, as in 'The Loretto Necklace', painted on his return and exhibited at the Royal Academy in 1829, the foreground is occupied by a scene of everyday life instead of one taken from ancient history or mythology, and the composition, though based on the same general scheme as that of 'The Bay of Baiæ', is simpler and less contrived.

Throughout this decade Turner's oil sketches, like the watercolours done in Italy in 1819, were much less conventional than the finished oils. Typical in their free, liquid technique are the two panels showing George IV on his state visit to Edinburgh in 1822 (plate 2), to witness which Turner made a special journey, though no finished pictures were painted. The same fresh handling is found in the sketch for the large painting of 'The Battle of Trafalgar', commissioned by George IV in 1823 and now in the National Maritime Museum, Greenwich. In 1827, when staying with the architect John Nash at East Cowes Castle on the

Isle of Wight, Turner painted nine small sketches including vivacious impressions of racing yachts (plate 6) and calm scenes of shipping at Cowes (plate 5) which were used for two pictures exhibited the following year (the finished painting of the latter subject is in the Victoria and Albert Museum). Also in this group are the exquisite 'Shipping off a Headland', the first of Turner's oils fully to recapture the delicacy of the Venetian watercolours of 1819, together with what seems to be his first study in oils of the sea and sky unrelieved by shipping or other incident, a rather tame forerunner of the stormy sea-pieces of the next decade.

A group of oil sketches of Italian subjects on coarse canvas almost certainly dates from Turner's visit of 1828–29: one of them is for the large 'Ulysses deriding Polyphemus' exhibited in 1829 and now in the National Gallery. Like the Cowes sketches some of them were painted on a single large canvas, presumably for ease of transportation, but they are very different in style. Boldly painted in broad areas of blue, white and different shades of brown with occasional flecks of thick impasto, their subtleties of colouring are obtained by the juxtaposition of different tones rather than by delicate glazes. Some, like 'Lake Nemi' or 'Ariccia', are sunlit panoramic views, of the same general type as his other Italian landscapes but much bolder in treatment and without their literary associations. Others are marked by a new sombre and threatening mood, for instance 'Archway with Trees by the Sea' (plate 7). 'Rocky Bay with Figures' (plate 9), though similar to the former group in mood, is closer in technique to the Cowes sketches and may be the commencement of a finished picture paralleling the 'Ulysses deriding Polyphemus', particularly as its composition is based on two of the sketches on coarse canvas. The degree in which certain of Turner's oils are 'unfinished' pictures rather than sketches will be discussed later.

A group of smaller sketches on millboard was probably also painted on the 1828–29 visit. Most of them show what can definitely be identified as Italian scenes and seem to reflect Turner's first impressions of visual effects such as the sun setting over the Gulf of Naples (plate 8). They

may have been a substitute for the watercolour sketches of the earlier trip and were perhaps actually painted on the spot, a very rare practice for Turner, like the Thames sketches of twenty years before.

The George IV sketches (plate 2) and one of the Cowes group, 'Between Decks', reflect Turner's growing interest in figure-subjects during the 1820's, an interest also shown in the Watteauesque 'Boccaccio relating the Tale of the Birdcage', exhibited in 1828. This interest received a new impetus from the patronage of the art-loving third Earl of Egremont. Of the pictures that Turner had begun in Rome in 1828 the landscape 'Palestrina' had been intended for this patron, who however chose instead the study of a girl at a window, 'Jessica', illustrating *The Merchant of Venice.* This painting, exhibited in 1830, is still at Lord Egremont's home, Petworth, but the Tate Gallery's 'Pilate washing his Hands' (plate 13), exhibited the same year, and 'Shadrach, Meshach and Abednego in the Fiery Furnace' of two years later, show the same influence of Rembrandt in their composition, texture and dramatic contrasted lighting, allied with a use of colour which, though also derived from Rembrandt, is far more brilliant and produces a completely personal effect.

From about 1830, the year after his father's death, until 1837 when Lord Egremont himself died, Turner was a regular and privileged visitor at Petworth with his own studio. The influence of the Petworth Van Dycks can be seen in the oil sketch of 'A Lady putting on her Glove' and in the first of a pair of small paintings exhibited in 1831, 'Lord Percy under Attainder'. The companion 'Watteau Study by Fresnoy's Rules' combines a tribute to the French painter with a demonstration of the observation in Charles du Fresnoy's *De arte graphica* on the effect of white in bringing a form forward in the picture-space or making it recede. Lord Egremont's purchase in 1827 of Hoppner's 'Sleeping Venus with Cupid' seems to have provoked Turner's nude study, 'Woman reclining on a Couch', which, with its allusions to Titian's 'Venus of Urbino', recalls Turner's earlier challenges to the Old Masters.

More important, Lord Egremont's patronage led to what are often regarded as Turner's finest landscapes, the oil sketches of Petworth Park, Chichester Canal, Brighton and a ship aground that are now shared between the National Gallery and the Tate. These were done about 1830–31 in connection with the four finished oils of similar subjects now at Petworth and their exceptionally long format reflects the original position of these finished works, placed as it were like predella panels below the full-length seventeenth-century portraits in the panelled dining-room. The delicate colouring of 'The Chain Pier, Brighton' and 'Ship aground' (plate 12) stems from the Cowes sketches of 1827, while the lozenge-shaped design of 'Petworth Park: Tillington Church in the Distance' (plate 11), with the almost palpable arch of its sunset sky, shows Turner's growing practice of making every part of a picture contribute equally to its composition instead of leaving the sky as a relatively passive foil to the landscape below.

A group of small gouaches on blue paper (T.B. CCXLIV) demonstrates how Turner's interests at Petworth were shared between landscape and interior scenes, the latter often reflecting the easy-going atmosphere of the company there. The gouaches of figures in conversation, at table, in front of the fire and so on were followed by a number of oils such as 'Music at Petworth' and 'The Letter' (plate 21), whose progressively bolder technique and thicker impasto suggest that they were painted well into the 1830's; like the gouaches they were never exhibited during Turner's lifetime. The series culminates in the extraordinary 'Interior at Petworth' (plate 1), a figure-subject without figures in which some elemental force of dissolution seems perhaps to echo the end of Turner's happy association with Petworth at the death of Lord Egremont in 1837. The restraint of the Petworth landscapes is replaced by violence, and form, colour and brush-strokes are all but completely liberated from the exigencies of natural appearances.

At the same time, in works not connected with Petworth, Turner had already moved away from the calm serenity that marks his landscapes of

around 1830. This serenity is still apparent in 'Bridge of Sighs, Ducal Palace, and Custom House, Venice: Canaletto painting' (plate 14), one of the first two oils of Venetian subjects to be exhibited by Turner in 1833, after which remarkably late date Venice became the inspiration for many of Turner's greatest works. 'Van Tromp returning after the Battle of the Dogger Bank' (plate 18), exhibited the same year, continues the series of Dutch-inspired sea-pieces that had occupied Turner periodically since 1800, but he was already becoming more and more concerned with the destructive forces of nature for their own sake. in a series of unexhibited but roughly datable oil paintings of stormy seas Turner's technique became increasingly identified with his theme: these include 'Rough Sea' (plate 16) of the early 1830's, 'Waves breaking on a Lee Shore' (plate 17) of *circa* 1835, and 'Stormy Sea' (plate 20) of the late 1830's or early 1840's. Even the earlier of these paintings, though at first sight more or less monochrome, often contain flecks of brilliant blue, pink, red and yellow which add an element of vibrancy to the colouring, while the last is an all but abstract expression of light, colour and energy. This release from conventional modes of representation (first achieved by Turner, paradoxically enough for an artist whose primary interest was landscape, in 'Interior at Petworth') finally spread from Turner's stormy sea-pieces to the calmer waters of 'Yacht approaching the Coast' (cover) and 'Sun setting over a Lake', both probably painted between 1840 and 1845.

One particular incident that spurred Turner's interest in the elemental forces of nature, in this case fire and the dramatic effect of light against darkness, was the burning of the Houses of Parliament in 1834. He portrayed this event in watercolours and oils, but its influence is also found in a number of works of the next few years including the gouaches on brown paper of Venetian night scenes with rockets (T.B. CCCXVIII), painted on a second visit to Venice in 1835, and, of his oils, the National Gallery's 'Fire at Sea' and possibly the Tate's 'Stormy Sea with burning Wreck' (plate 19). With the exception of the two finished oils of the

burning of Parliament none of these works was exhibited by Turner. Even the stormiest of the exhibited paintings continued to be more conventional, particularly in their degree of finish, until the 1840's.

Eye-witness accounts of Turner's procedure on the varnishing days preceding the openings of the annual Royal Academy and British Institution exhibitions show that from at least as early as 1835 the 'finish' of his exhibited pictures was frequently added at the very last moment. He is described as having arrived with a canvas no more than laid in with blue for sea or sky and yellow shading through orange into brown where there were to be trees or landscape, and as having then worked this up into a finished picture, presumably adding the details of his historical or mythological subject as he went. Many of Turner's most ravishingly delicate oils are just such lay-ins—'Sunrise, a Castle on a Bay' (plate 24), 'Bridge and Tower', 'A Harbour with Town and Fortress' (plate 23), 'Sunrise: Shipping between Headlands' and 'Norham Castle' (plate 30)—and many others must lie beneath the finished works. Some of the more finished yet unexhibited paintings such as 'The Arch of Constantine, Rome' (plate 22) and 'Yacht approaching the Coast' (cover) show a stage beyond this but were presumably regarded as insufficiently finished to be shown to the public. The former, with the thick paint of the sky overlapping the thin flatly painted tree on the left, is very much a work in progress. These paintings almost certainly date from the later 1830's or 1840's and the Petworth landscapes of *circa* 1830–31 show that at that date Turner was still painting his sketches on separate canvases, but examples of sketches which may have been intended to be themselves developed into finished pictures can also be dated to about 1830, the 'Rocky Bay with Figures' already mentioned, 'The Thames near above Waterloo Bridge', 'Southern Landscape with an Aqueduct and Waterfall' (plate 15) and the National Gallery's 'Evening Star'.

In the 1840's the dichotomy between Turner's exhibited and unexhibited pictures, both in technique and adventurousness, tended to disappear.

This can be seen by comparing the Tate Gallery's unexhibited 'Yacht approaching the Coast' (cover) with the National Gallery's 'Snow Storm—Steam-Boat off a Harbour's Mouth making Signals', exhibited in 1842. The latter is as advanced in technique as the former and in both the dominating vortex-like composition is freely expressed. In both pictures Turner was working on subjects that directly reflected his underlying interests and this became true of the majority even of his exhibited works. Venice became a constant theme and while 'Canaletto Painting' (plate 14), exhibited in 1833, had been given a historical association the majority of later examples were self-sufficient in their evocation of the beneficial power of the Italian sun, reflecting off stone and water: for instance 'The Dogano, San Giorgio, Citella, from the Steps of the Europa' (plate 26), exhibited in 1842. Similarly with sea-pieces: historical subjects such as 'Van Tromp returning after the Battle of the Dogger Bank' (plate 18), exhibited in 1833, were supplemented by less specific contemporary subjects such as the whaling scenes taken from Beale's *Voyages* and exhibited in 1845 and 1846 (plate 29). The most outstanding examples of this growing identification of Turner's exhibited works with his deepest interests are two pictures in the National Gallery, the 'Snow Storm' already mentioned and 'Rain, Steam and Speed', exhibited in 1844, both of which set a man-made construction in the midst of the warring elements of nature.

A more personal impulse lay behind 'Peace—Burial at Sea' (plate 25), exhibited in 1842 as a tribute to the painter Sir David Wilkie who had died on the way home from Egypt the previous year. The angular black sails, echoed by the bird in the foreground, express Turner's grief at the death of his friend. The format of this work and a number of Turner's other exhibits between 1840 and 1846, which were painted on square canvases, the compositions sometimes circular or octagonal with the corners cut across, helped to concentrate the design and was particularly suited to the whirlpool-like compositions of such pictures as 'Shade and Darkness—the Evening of the Deluge' and its companion

'Light and Colour (Goethe's Theory)—the Morning after the Deluge—Moses writing the Book of Genesis' (plate 27), both exhibited in 1843. Here, though Turner had fallen back on the Bible for his ostensible, and somewhat ill-digested, subjects, his real interest was Goethe's theory of the contrasted emotional effects of the two halves of the 'colour circle' (a variant of the prismatic scale): the cold blues and purples of 'Shade and Darkness', colours seen by Goethe as being conducive to 'restless, susceptible, anxious impressions', are opposed to the warm reds and yellows of the other, more optimistic, picture. As in other works of the 1840's the figures merge into the forms of the landscape, producing a new unity of design. Another example of a vortex-like composition in this format is 'The Angel standing in the Sun' (plate 28), exhibited in 1846, in which Turner transformed the text of *The Book of Revelation*, quoted in the Royal Academy catalogue, into an Apocalyptic vision of his own, that of the all-embracing, all-engulfing power of light. This picture marks, appropriately enough, the end of Turner's achievement as a creative artist. In 1847 and 1849 (he showed nothing in 1848) he exhibited three works painted some forty years earlier, two of them refurbished: in 'The Hero of a Hundred Fights' exhibited in 1847 the newly painted glow of the furnace lies uneasily on the original dark-toned, dryly-painted interior. Finally, in 1850, he exhibited four new works on the theme of Dido and Æneas, stereotyped in composition, inharmonious in colour and turgid in handling. On 19 December 1851, having failed to show anything at that summer's Royal Academy, he died.

As the result of legal proceedings after his death which overruled the terms of his will the entire contents of Turner's studio, nearly 300 oil paintings and over 19,000 watercolours, drawings and sketchbook pages, entered the national collection. The oils are now divided between the National Gallery and the Tate; the other works are in the Department of Prints and Drawings at the British Museum. But this magnificent inheritance does not, it seems, reflect Turner's own intentions. Although

he had preserved even the scrappiest of his sketches it was, in all but the first codicil of his will, solely 'my finished pictures' that he wished to be preserved by the National Gallery in a special Turner Gallery. In this, as in the importance he attached to giving subjects to his finished works, which were often exhibited with literary references or his own rather turgid verses (purporting to come from an epic *Fallacies of Hope*), his assessment of the nature of his achievement differs radically from today's. But, while the prizing above all of Turner's unexhibited oil sketches and watercolours is probably justified, appreciation of his work can be deepened by taking his own intentions into account. For in a sense all Turner's pictures, even the sketches, were subject pictures. They were not impressions of landscape but visionary statements about landscape, about the forces of nature, whether life-giving or destructive, that underlie natural appearances. Thus Turner, although his work was based on phenomenal powers of observation, differed fundamentally from such artists as Constable and the Impressionists whose starting point was the everyday world of optical reality.

Turner's desire to express themes of significance was in part influenced by the artistic theory, current in his youth, of a hierarchy of the genres of painting in which mere landscape ranked well below history-painting, that is the depiction of improving religious, historical or mythological subjects. Turner's early emulation of Poussin's historical landscapes and the very scheme of his *Liber Studiorum*, a demonstration of the different categories of landscape, show his awareness of such distinctions. In addition he seems to have had a genuine desire to treat themes of human significance, but for a long time he was unable fully to realize his ambitions within the field, landscape painting, in which he found his natural mode of expression. This led to what now seems to be his rather misguided urge during much of his career to give specific historical or mythological subjects to his pictures, often literally superimposing them over exquisite sketches on the last few days before their exhibition. The inaccuracies found in the wording of many of his titles show that these

subjects were not fundamental to his paintings. They should rather be seen as labels designed to justify, sometimes in a moral sense, his own more general intentions, which were often nothing more specific than the evocation of the emotion aroused by some ancient site or bygone incident. Even so his subject-pictures are usually more successful when allied to the depiction of some natural phenomenon, such as the storm in 'Hannibal crossing the Alps', to take an example from his earlier works, or to some artistic problem, such as the emotive value of different colours in the 'Goethe's Theory' paintings (plate 27).

Turner's technique and the very way in which he portrayed nature developed in accord with his growing vision of its basic forces and with his gradual realization that these forces were of far greater significance for the human situation than the elevated subjects he had been adding to his landscape compositions. In his best works his technique became perfectly attuned to his real theme, whether in the delicate glazes, translucent colour and calm balanced design of 'Norham Castle' (plate 30) or in the thick energetic handling, strong vibrant colour and whirlpool-like composition of 'Yacht approaching the Coast' (cover). Turner's range had always been wide but in such late works as these the somewhat disparate interests of his earlier career were reconciled by an overriding unity of purpose.

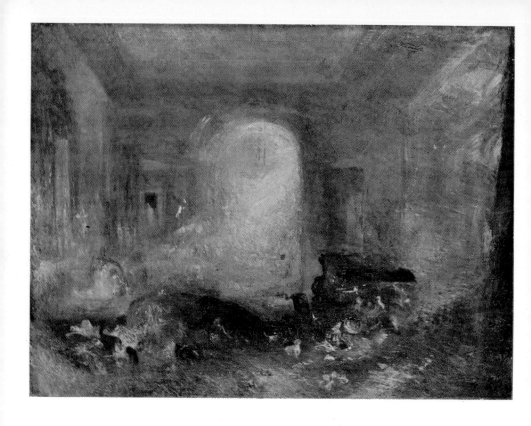

1 *Interior at Petworth. c.*1837
Canvas, 35¾ × 48 in. (1988)

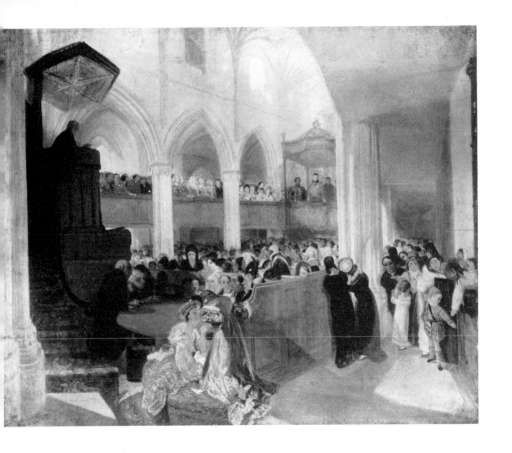

2 *George IV at St. Giles', Edinburgh.* 1822
Panel, 29 × 35¼ in. (2857)

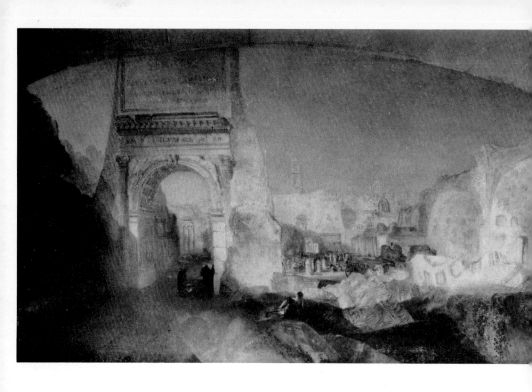

3 *Forum Romanum.* exh. 1826
Canvas, $57\frac{1}{2} \times 93\frac{1}{2}$ in. (504)

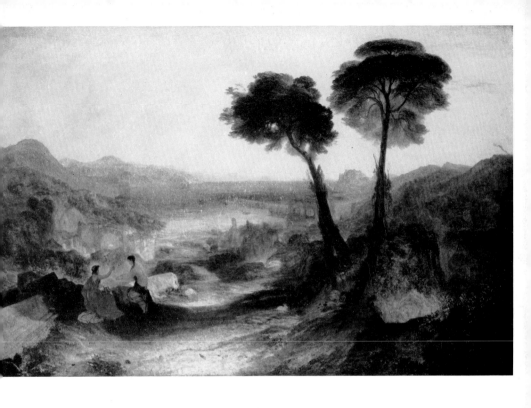

4 *The Bay of Baiæ, with Apollo and the Sibyl.* exh. 1823
Canvas, 57½ × 93½ in. (505)

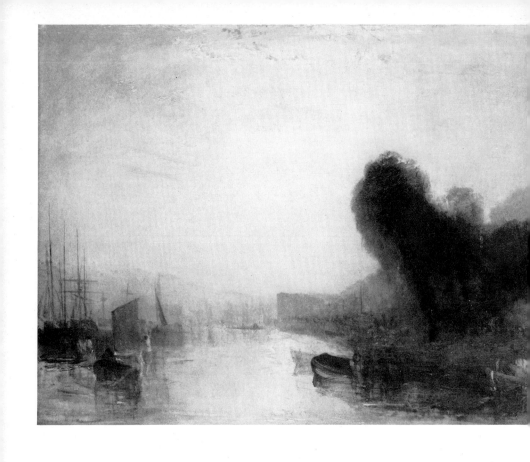

5 *Shipping at Cowes, No. 1*. 1827
Canvas, $18\frac{1}{4} \times 24\frac{1}{4}$ in. (1998)

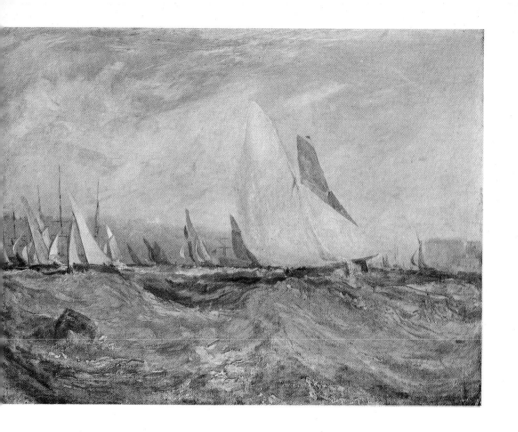

6 *Yacht Racing in the Solent, No. 2.* 1827
Canvas, 18×24 in. (1994)

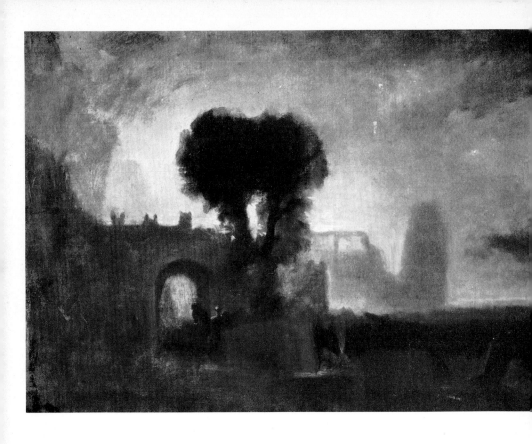

7 *Archway with Trees by the Sea.* 1828 (?)
Canvas, $23\frac{1}{2} \times 34\frac{1}{2}$ in. (3381)

8 *Coast Scene near Naples.* 1828 (?)
Millboard, 16 × 23½ in. (5527)

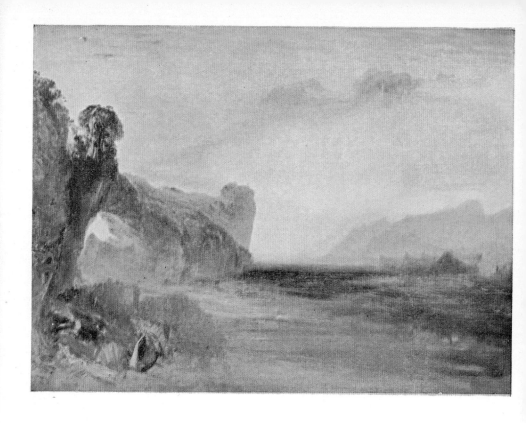

9 *Rocky Bay with Figures. c.*1828–30
Canvas, 35½×48½ in. (1989)

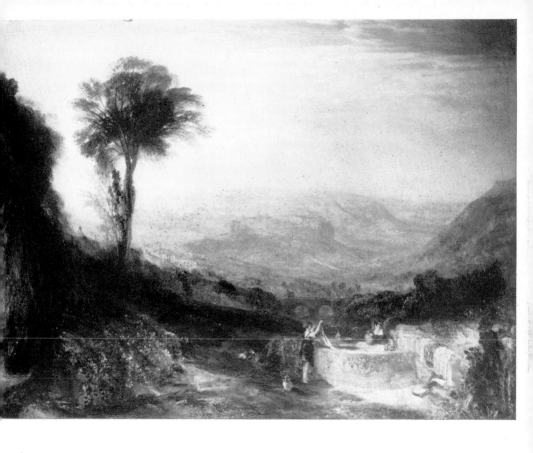

10 *Orvieto.* 1828
Canvas, 36 × 48 in. (511)

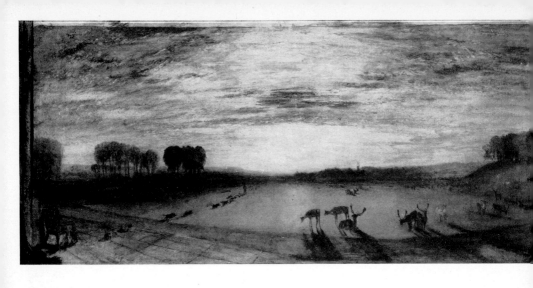

11 *Petworth Park, Tillington Church in
the Distance. c.*1830–31
Canvas, $25\frac{1}{4} \times 58\frac{1}{4}$ in. (559)

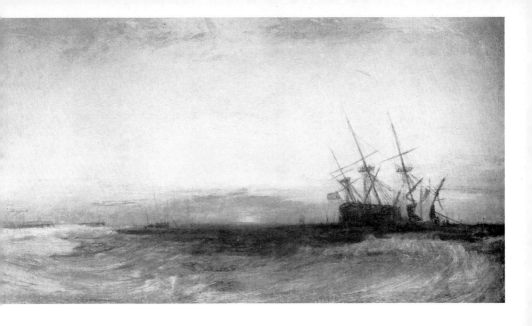

12 *A Ship aground. c.*1830–31
Canvas, $27\frac{1}{4} \times 53\frac{1}{4}$ in. (2065)

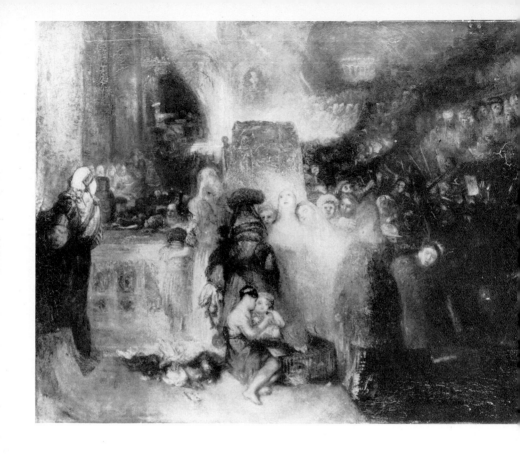

13 *Pilate washing his Hands.* exh. 1830
Canvas, 36 × 48 in. (510)

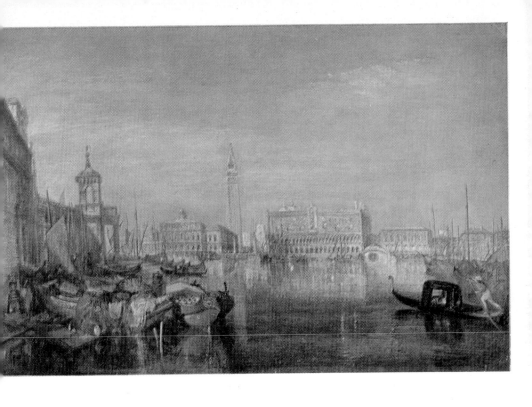

14 *Bridge of Sighs, Ducal Palace, and Custom House, Venice: Canaletto painting.* exh. 1833 Canvas, $20\frac{1}{4} \times 32\frac{1}{2}$ in. (370)

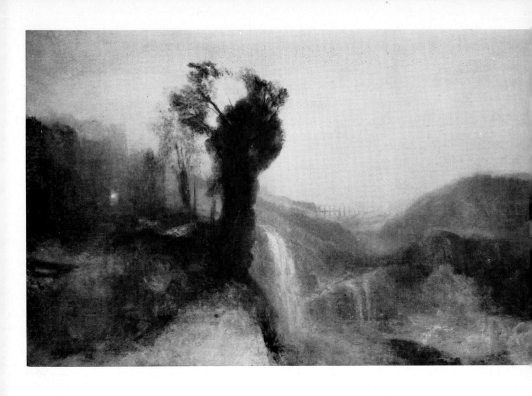

15 *Southern Landscape with
Aqueduct and Waterfall. c.*1830
Canvas, $58\frac{3}{4} \times 98\frac{1}{2}$ in. (5506)

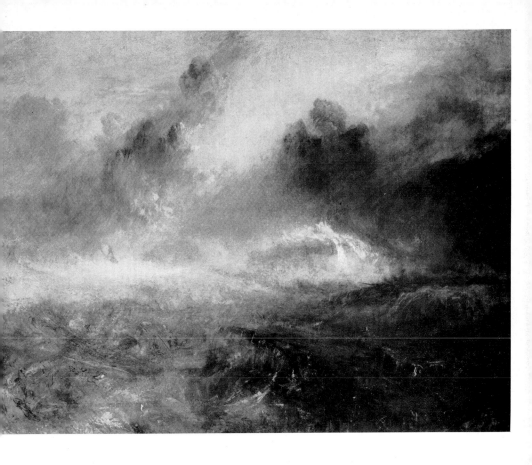

16 *Rough Sea. c.*1830–35
Canvas, 36 × 48½ in. (1980)

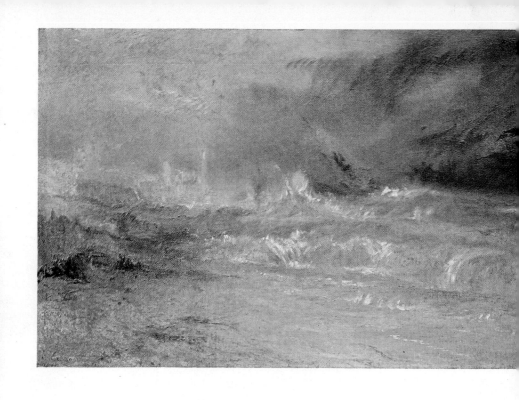

17 *Waves breaking on a Lee Shore. c.*1835
Canvas, 23 × 35 in. (2882)

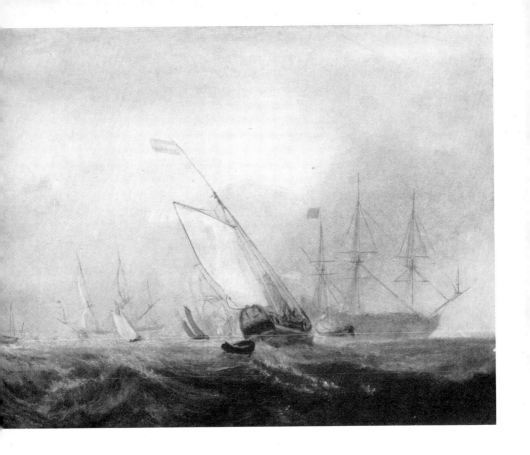

18 *Van Tromp returning after the Battle of the Dogger Bank.* exh. 1833
Canvas, 36 × 48 in. (537)

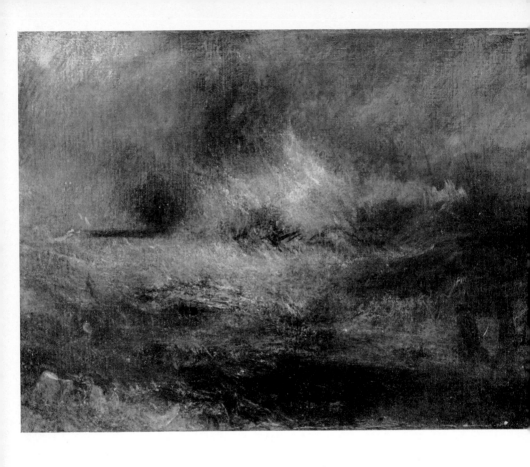

19 *Stormy Sea with Blazing Wreck. c.*1835 (?)
Canvas, $39\frac{1}{4} \times 55\frac{3}{4}$ in. (4658)

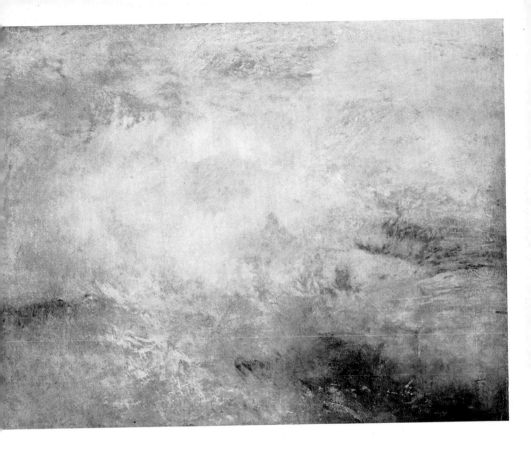

20 *Stormy Sea. c.*1835–40
Canvas, 36 × 48 in. (4664)

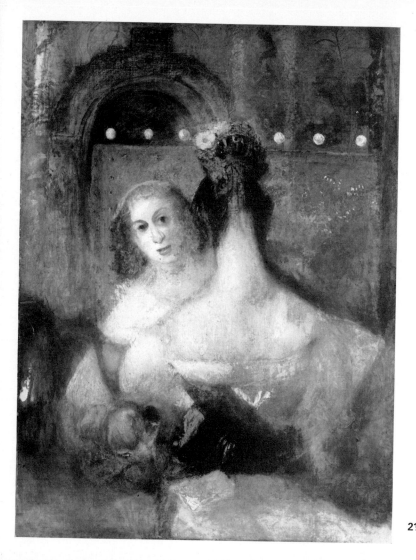

21 *The Letter.* c.1835
Canvas, 48×36 in. (

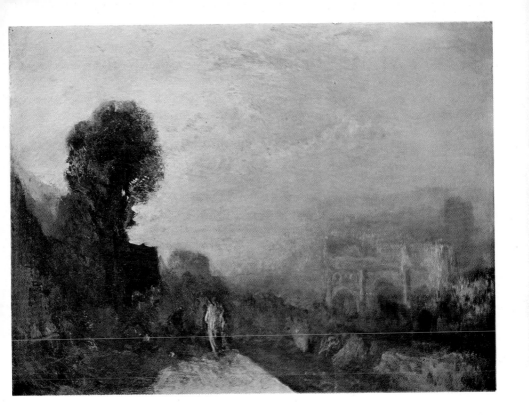

22 *The Arch of Constantine, Rome. c.*1835
Canvas, 36×48 in. (2066)

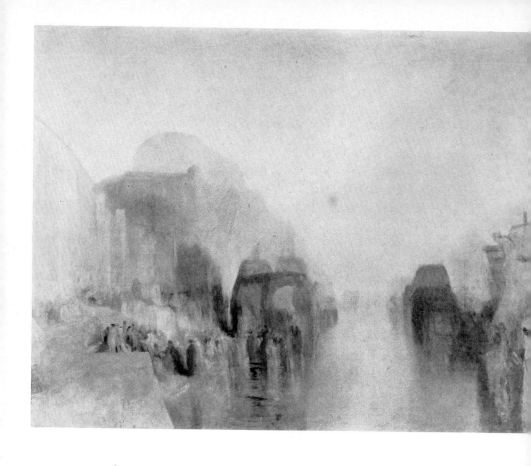

23 *A Harbour with Town and Fortress.* *c.*1835–40
Canvas, 68×88 in. (5514)

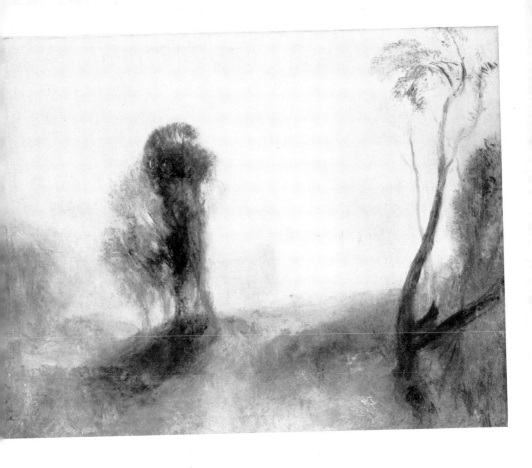

24 *Sunrise, a Castle on a Bay. c.*1840
Canvas, 36×48 in. (1985)

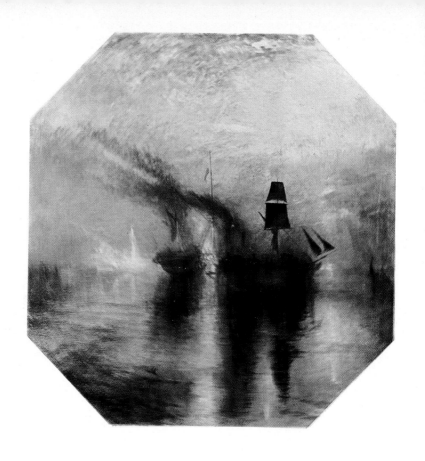

25 *Peace—Burial at Sea.* 1841–42
Canvas, $34\frac{3}{4} \times 34\frac{3}{4}$ in. (528)

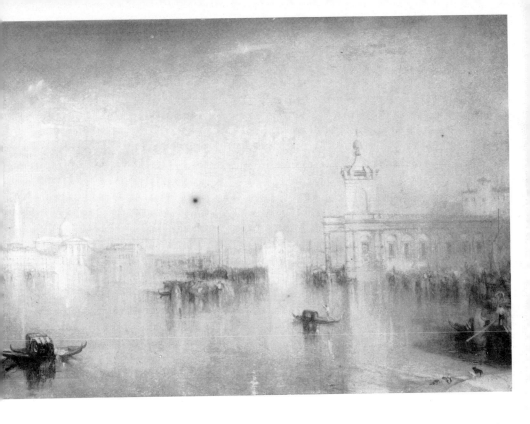

26 *The Dogana, San Giorgio, Citella, from the Steps of the Europa.* exh. 1842
Canvas, $24\frac{3}{4} \times 36\frac{1}{2}$ in. (372)

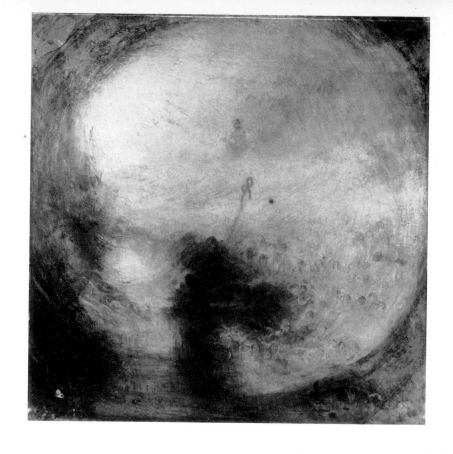

27 *Light and Colour (Goethe's Theory)—The Morning after the Deluge—
Moses writing the Book of Genesis.* exh. 1843
Canvas, $30\frac{1}{2} \times 30\frac{1}{2}$ in. (532)

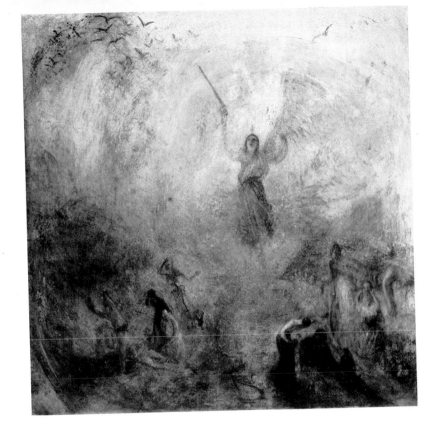

28 *The Angel standing in the Sun.* exh. 1846
Canvas, 30½ × 30½ in. (550)

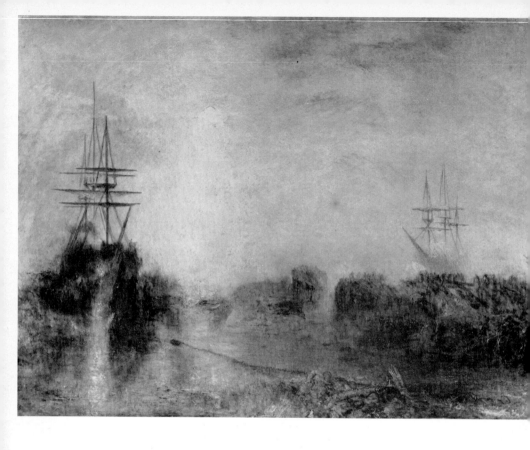

29 *Whalers (boiling blubber) entangled in Flaw Ice,
endeavouring to extricate themselves.* exh. 1846
Canvas, 36 × 48 in. (547)

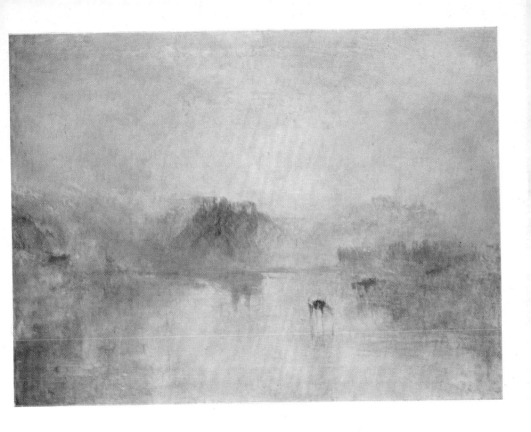

30 *Norham Castle, Sunrise. c.*1840–45
Canvas, 36×48 in. (1981)